DRAW

500

FACES

AND

FEATURES

A Sketchbook for Artists, Designers, and Doodlers

CARA BEAN

Quarry Books
100 Cummings Center, Suite 406L
Beverly, MA 01915

quarrybooks.com • www.craftside.net

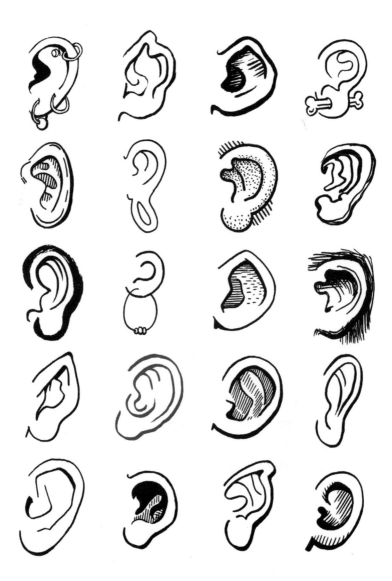

HOW TO USE THIS BOOK

Draw 500 Faces and Features is a fun and interactive book designed to help you explore a wide variety of approaches to drawing a multitude of themes. Some are very simple; some are more complex. Some are realistic while others are reduced to their most basic geometric elements. Some drawings are rendered accurately; others ignore scale and proportion. Look at the images and select those that interest you. Can you draw something similar or improve on the image? Discover new ways to reconfigure the shapes and lines that you see.

Some pages are blank for you to fill, while others have spaces for you to draw between the images. Maybe you can combine various features to invent new characters? Perhaps you will make monsters with twenty different kinds of eyes? Try putting a mustache on a cat or a beard on a dog! Become comfortable with the idea that you can express yourself through drawing. Draw in a way that surprises and captivates your imagination, exploring different drawing tools and applying different techniques. Enjoy the process and interpret your mistakes as potential creative possibilities. Enjoy the idea that we can draw funny features in as many ways as we can imagine!

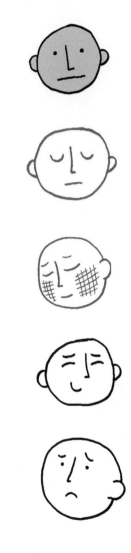

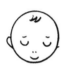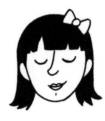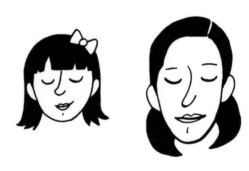

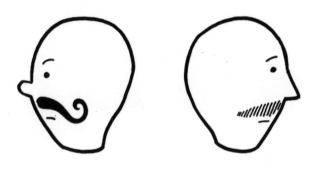

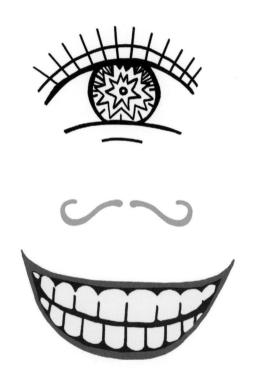

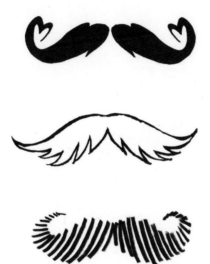

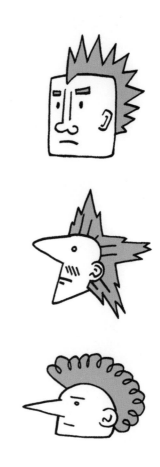

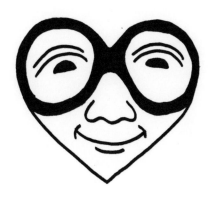

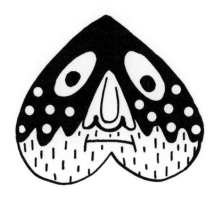

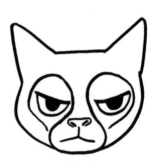

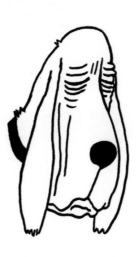

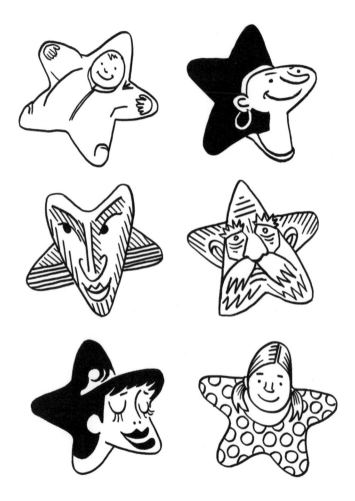

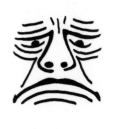
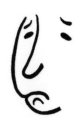
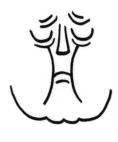

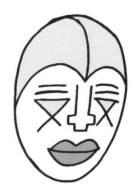 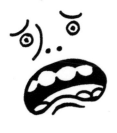

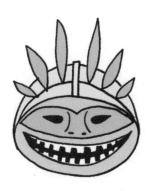

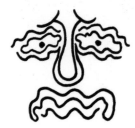

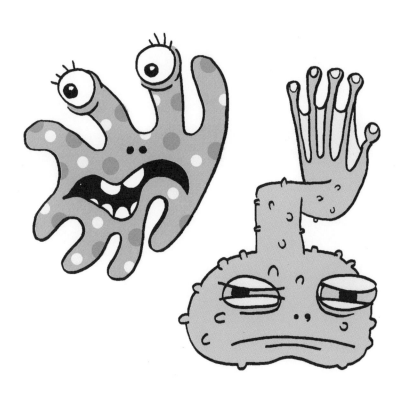

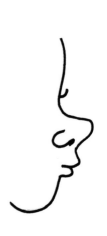

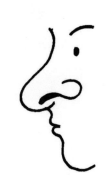

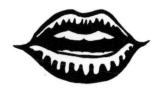

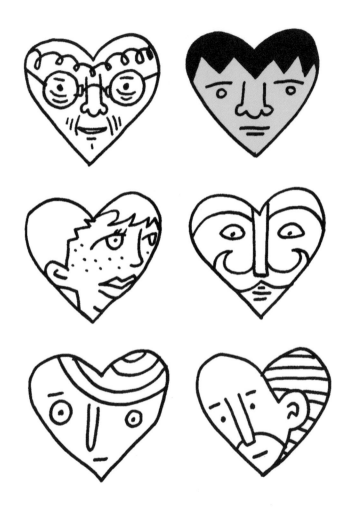

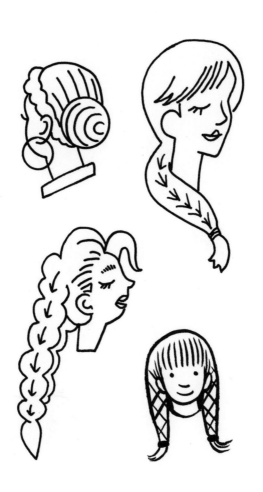

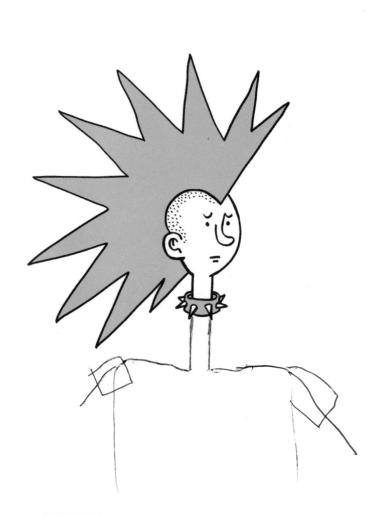

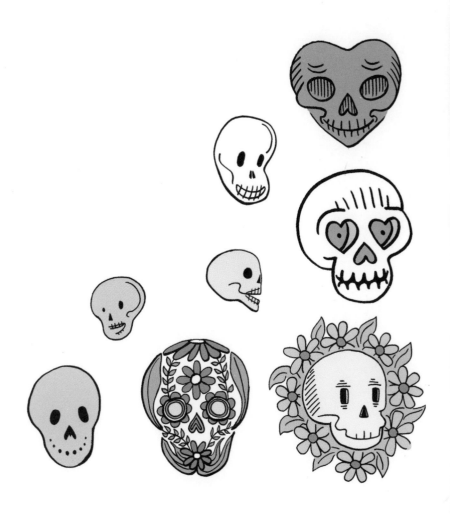

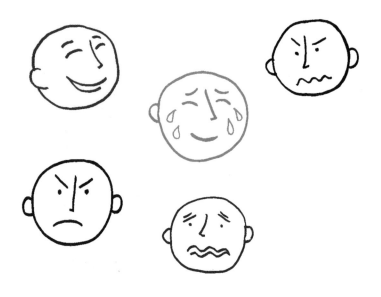

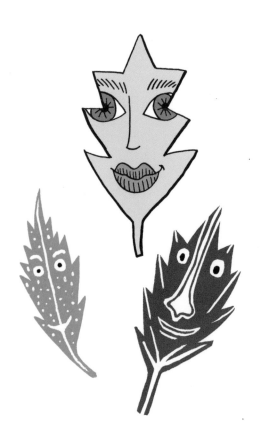

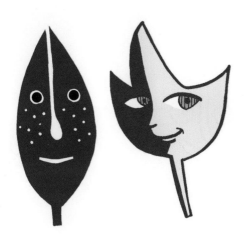

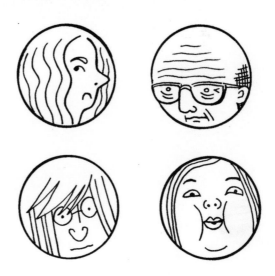

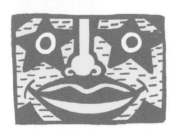
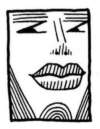

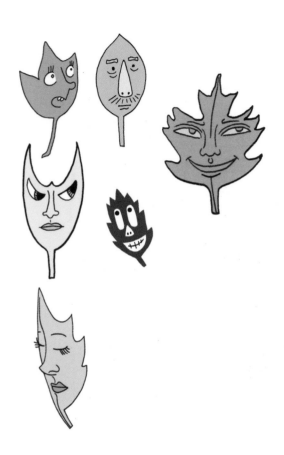

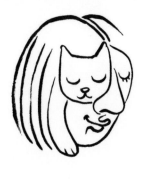

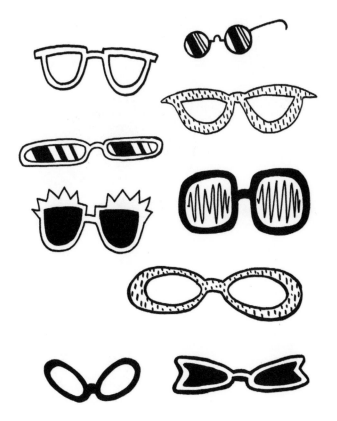

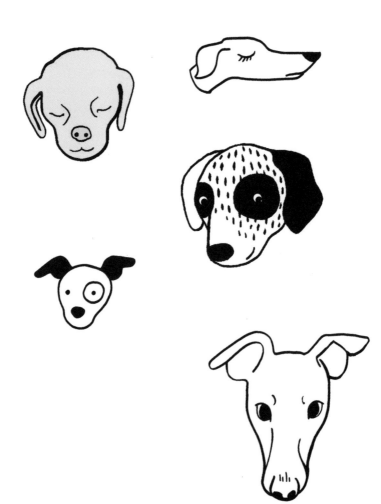

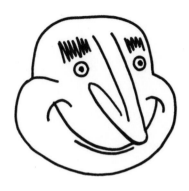
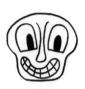

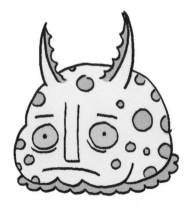

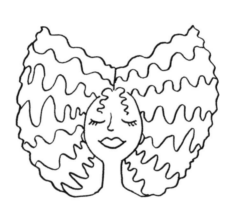

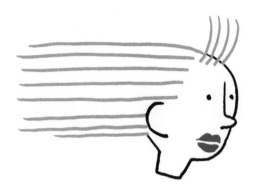

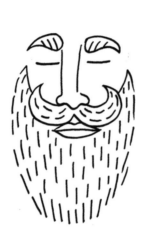

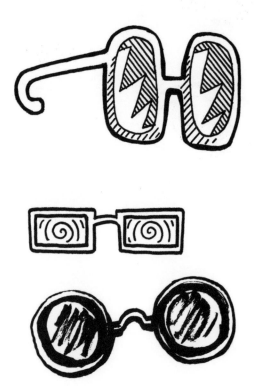

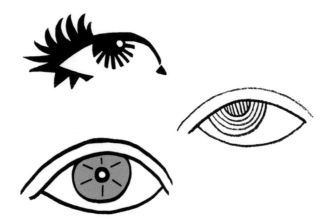

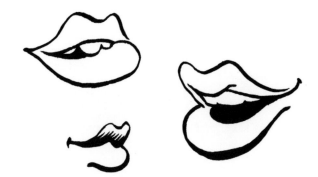

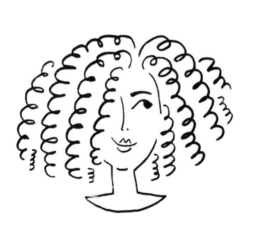

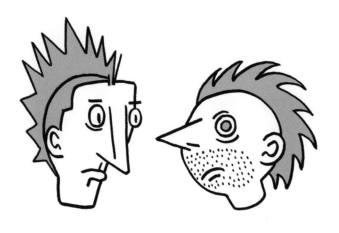

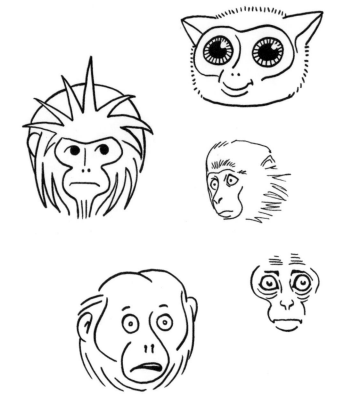

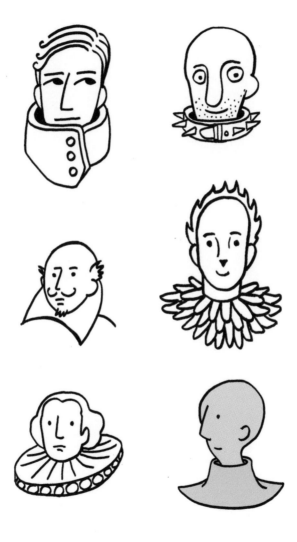

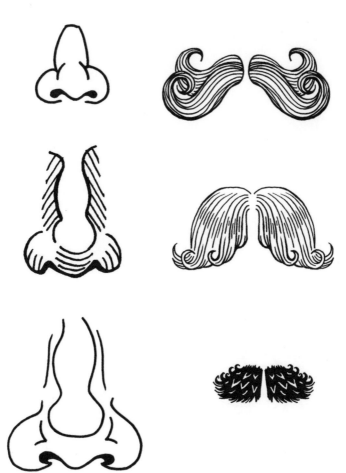

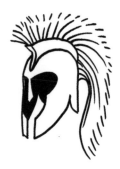

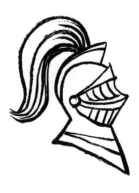

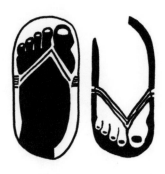

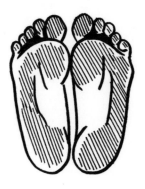

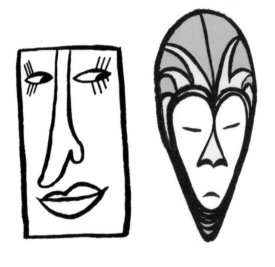

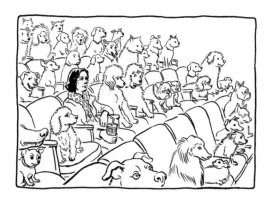

ABOUT THE ARTIST

Cara Bean is a cartoonist and art teacher from Concord, Massachusetts. She graduated with a master's degree in painting and drawing from the University of Washington in Seattle. When she is not teaching, she makes comic books that relate to her life's experiences and fills sketchbooks with strange doodles.

Cara likes dogs, apes, tea, green hoodies, soup with crusty bread, people who walk alone and smile to themselves, hikes, mangoes, befriending shy people, cats, libraries, thrift stores, Guadalajara, dancing with babies, crunchy leaves, owls, and nachos. Her students gather on Tuesdays after school for Illustration Club, which has become a place to draw and share ideas. Cara lives in a small cottage near Walden Pond with three wild dogs named Howie, Jackie, and Jon. Learn more about Cara Bean at: badgigi.com, beandoodling.blogspot.com.

First published in the United States of America in 2015 by
Quarry Books, a member of
Quarto Publishing Group USA Inc.
100 Cummings Center
Suite 406-L
Beverly, Massachusetts 01915-6101
Telephone: (978) 282-9590
Fax: (978) 283-2742
www.quarrybooks.com
Visit www.craftside.net for a behind-the-scenes peek at our crafty world!

10 9 8 7 6 5 4 3 2 1

ISBN: 978-1-63159-090-0

All artwork compiled from *20 Ways to Draw a Mustache and 44 Other Funny
Faces and Features*, © 2014 Quarry Books

Design: Debbie Berne

Printed in China